Little Wimmin

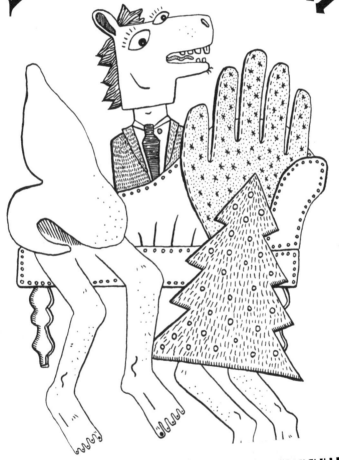

by Figs in Wigs

First published in 2020 by Salamander Street Ltd.

(info@salamanderstreet.com)

Copyright © Figs in Wigs, 2020

PB: 9781913630065

E: 9781913630072

Printed and bound in Great Britain

10 9 8 7 6 5 4 3 2 1

For Lou,
We couldn't have done it without you.
Read it and weep.

x

Little Wimmin was first performed at Pleasance Theatre, Islington, on 6th November 2019 with the following cast and creative team:

FLOATING ORACLE 1, MEG, GLOVE, RACH G	Rachel Gammon
FLOATING ORACLE 2, AMY, NOSE, SARAH	Sarah Moore
FLOATING ORACLE 3, BETH, MUCUS SACK, ALICE	Alice Roots
FLOATING ORACLE 4, JO, HORSE, RACH P	Rachel Porter
FLOATING ORACLE 5, CHRISTMAS TREE, SUE	Suzanna Hurst
Devised, directed and choreographed by	Figs in Wigs
Set Design Nose & Glove Costumes	Emma Bailey
Costume	Rachel Gammon
Lighting	Gene Giron
Sound	Suzanna Hurst & Alicia Jane Turner
Outside Eye & Fountain of Dramaturgical Wisdom	Ursula Martinez
Am Dram Direction	Hannah Maxwell
Astrologer	Madeleine Botet de Lacaze
Floating Oracle Apparatus	Fani Parali
Family Portraits	Frances Gibson
Technical Octopus	Sorcha Stott-Strzala
Production Manager	Helen Mugridge

ACKNOWLEDGEMENTS

Co-commissioned by HOME Manchester and Cambridge Junction with the support of Stobbs New Ideas Fund. Supported by Arts Council England

Thank you to everyone of all genders that helped us make this show happen:

Nao Nagai, Xoey Fourr, Julie Rose Bower, Chris Brett Bailey, Frances Gibson, Ryan Malcom, Jonathan Pointing, Bob Mottram, Gino Saccone, Battersea Arts Centre, New Wolsey Ipswich, New Diorama, Queen Mary University, Streatham Space, Pleasance Theatre, The Depot, SET, Duckie, The Glory, Passion4Ice

Thank you to everyone who helped bring this masterpiece to life in a literary form:

Published by George "Big Spender" Spender and all the lizards at Salamander St

Design by Kaiya Waerea

Cover Illustration by Frances Gibson

CHARACTERS

THE FLOATING ORACLES
Mystical, all-knowing, levitating wisdom

THE MARCH SISTERS
JO
Tomboy, loves reading and writing, Sagittarius
MEG
The eldest sister, kind with a weakness for luxury
AMY
The youngest March sister, has a temper
BETH
Quiet, virtuous, loves music

THE BURDENS
CHRISTMAS TREE
A tree, forced to act as a Christmas tree in the play
HORSE
Half boy, half horse
GLOVE
A right hand giant lacey glove, pregnant
NOSE
A fuming, nosey parker
MUCUS SACK
Beth's phlegm

THE FIGS
ALICE
Cancerian Scouser
RACHEL G
Virgo from Ladywell
RACHEL P
A Pisces from Norwich (East Anglia's New York City)
SARAH
Cancerian Wiganite
SUZANNA
Sagittarian from (The) Wirral

NB. for future staging, whenever characters refer to each other using the performer's name, this should be replaced with the name of the performer currently playing that part.

Act 1

scene one
An Explanation

A spacey retro-futuristic soundscape plays. The curtain slowly rises, bright white light spills through the crack and haze escapes into the auditorium. The stage floor is covered in white fabric, piled, twisted and crumpled. Five steel poles emerge from the heap. The curtain rises further to reveal five figures floating onstage, their right hands resting atop the very long steel canes, the other end of which is their only point of contact with the floor. The piles of white fabric continue behind them stretching up to the rig creating an infinity backdrop. They are dressed identically each wearing a pale pink glittery robe (slanket), what can only be described as a Sharon Osborne style wig and a cloud for a hat. They look like a cross between the levitating Yoda street performers usually found outside the National Gallery and the angels from the 90's Philadelphia cream cheese television adverts.

FLOATING ORACLE 1 Hello and welcome. We are Figs in Wigs and this is Little Wimmin. Now you may be thinking we are not that little. You may be thinking we are about 55cm taller than you imagined or remembered. But don't worry, we are here to explain everything.

FLOATING ORACLE 2 Originally we were going to do this bit at the end[1] and explain everything to you with the benefit of hindsight. However we asked ourselves the age old question: is it more fun to know what's going on, or not?[2]

FLOATING ORACLE 3 Is ignorance bliss? We just don't know.[3]

FLOATING ORACLE 4 But what we do know is that right now you are more ignorant than us. But we don't want to be above you. We are all about equality... so let's bring you up to our level.

1 This in true Act One was originally Act Three.
2. In this case we concluded that it is more fun to know what's going on. Hence why Act Three is now Act One.
3. We do.

FLOATING ORACLE 5 At the end of the show we want you to walk out of here safely, without tripping over the gaping plot holes that we may leave behind.

FLOATING ORACLE 1 Yes, we are giving you this information so you can use it like a cosmic cement to smooth over any fictional cracks that you may find disturbing.

FLOATING ORACLE 4 Rest assured, We have carried out extensive research and development to make this show. We've all read the book, and we've watched the film three times.

FLOATING ORACLE 1 Suzanna is the only one who after reading the book had absolutely no interest in the story whatsoever. Which ultimately did the rest of us a favour as there are only four main characters anyway... Meg March.

FLOATING ORACLE 4 Jo - sephine March.

FLOATING ORACLE 2 Amy March.

FLOATING ORACLE 3 ...and Beth March. Despite appearances, we have paid huge attention to historical accuracy.

FLOATING ORACLE 5 For example, in our adaptation, you will notice that the March sisters have a lobster on their dining table. For those of you familiar with the book, you'll know that the March family never stop talking about how poor they are. So how could they possibly afford lobster?

FLOATING ORACLE 1 Well, interestingly, in the 1860s, Massachusetts was awash with lobster. It was a poor woman's food. People fed it to their pigs, until even the pigs refused to eat it because it was so common.

FLOATING ORACLE 2 In Chapter 2, 'A Merry Christmas', the March sisters each receive a copy of Pilgrim's Progress by John Bunyan. You may think it's odd that, in our adaptation, they instead receive a copy of Eat Pray Love by Elizabeth Gilbert.

FLOATING ORACLE 3 This is because Eat, Pray, Love is actually a modern day retelling of Pilgrim's Progress, where John Bunyan, beautifully portrayed by Julia Roberts in the film, goes on a long journey of self-discovery, after a messy divorce.

FLOATING ORACLE 4 And few people know that the common bunion was in fact named after John Bunyan, who suffered badly from them, after such a long journey.

FLOATING ORACLE 1 Chapter 4 is entitled 'Burdens'.[4] Rather like John's Bunyan, the March sisters each have a burden, which we will be exploring.

FLOATING ORACLE 4 Jo wishes she was a boy, and also a horse.

FLOATING ORACLE 2 Amy hates her nose.

FLOATING ORACLE 1 Meg wants nice, expensive things that she can't afford, like gloves.

FLOATING ORACLE 3 And Beth dies...... selfishly burdening her family with grief.

 ALL What a bitch.

FLOATING ORACLE 5 We will also explore the sisters' most memorable plot points:

FLOATING ORACLE 4 Jo cuts off her hair.

FLOATING ORACLE 2 Amy burns Jo's manuscript in a fit of rage.

FLOATING ORACLE 1 Meg has not one but two babies, at the same time....twins!

4. Early on in our rehearsal process we made a band inspired by Chapter 4 called Beth and the Burdens. They are an emo-post-punk-funk-noise-synth band, fronted by Beth, who dies. Right up until the dress rehearsal they were going to appear in Act Three and do a live set with songs including, Burdens, Live Experiment, Rage and Hornet. However setting up the band and playing the songs would have pushed the show over the 3 hour mark, and we felt we couldn't do that to our audience.

FLOATING ORACLE 3 …and Beth dies.

FLOATING ORACLE 1 You may have guessed by now that we do not perform the story chronologically. This is because time is a man-made construct. It is non-linear, it is evolving…… revolving, turning, in a circle…. in a hoop that never ends. How high does the sycamore grow? Well, if you cut it down, then you'll never know.[5]

FLOATING ORACLE 2 Which brings us to our next point, the tree. You will see that in our adaptation the tree plays a very important role.[6] The tree of course, represents trees. #notalltrees. Deforestation, the Amazon, Amazon, burning and dying.

FLOATING ORACLE 5 *(irate)* People used to care about trees, about wasting paper, but since plastic came along, no one gives a sheet. These days it's: "Here, have this paper bag, use this paper straw, don't worry it'll rot down." Well it might be bio-degrading but it's just plain degrading to trees.[7]

FLOATING ORACLE 4 Yes, thank you Sue.[8] That's right, the tree is a clue to the deeper message of the show.

FLOATING ORACLE 5 Yes. Little Wimmin isn't just about little women. It's not a show about small things.[9] No. It's also about big things. It's about…

5. From Colours of the Wind, the theme tune to Walt Disney's 1995 megahit Pocahontas. Lyrics by Stephen Schwartz.
6. The film Pocahontas also has a tree that plays an important role. However we are not talking about Grandmother Willow here. This is just one of those serendipitous coincidences.
7. Floating Oracle 5 also plays the part of the tree in Act Two, giving this line a nuanced gravitas and poignancy when thought about retrospectively. Sadly hindsight is a beautiful thing that the audience does not yet possess at this point so the brilliance of this double meaning is totally wasted on them. Instead FO5's fury can sometimes cause her to be misunderstood as an irritating tree hugger, dampening the mood by bringing climate change into the room, whereas in actual fact she is speaking from the heart, as she has been a tree and she knows their pain.
8. At this point FO4 refers to FO5 by their real name, as in the actor's nickname.
9. This is in reference to Figs in Wigs' 2013 show We, Object in which this line was frequently repeated.

Music cuts.

FLOATING ORACLE 5 CLIMATE CHANGE.

The music fades back up. A pause.

FLOATING ORACLE 2 Chapter 8 is called 'Jo Meets Apollyon'. In this chapter, they go skating on a frozen lake. Amy skates onto a thin patch of ice, falls into the water, and nearly drowns. We will be representing this chapter with an ice sculpture.

FLOATING ORACLE 1 Now the ice sculpture has many meanings, it's multi-layered. It not only represents the semifreddo lake that Amy falls into but as it slowly melts, it serves as a vital visual metaphor for what the actions of humans have done to the ice caps. Take a closer look and you will surely see that the ice sculpture is also representative of the patriarchy and Amy's desire, as an aspiring artist, to smash through the glass ceiling of the male-dominated art world.

FLOATING ORACLE 3 This is a topic close to our hearts and our arts. We too have experienced first-hand the icy cold shoulder of the patriarchy. In fact, we even made a short sound and movement piece entitled Beat the Rug, Beat the Patriarchy, based on our experiences.[10]

FLOATING ORACLE 4 Coincidentally, in Chapter 10 'Lazy Laurence', Laurie aka Laurence says to Amy, "Regard me in the light of a husband or a carpet, and beat me till you are tired, if that sort of exercise agrees with you." To which Amy replies, "You disgust me."[11]

10. This short sound and movement piece was actually created back in April 2017, long before we had started adapting Little Women. Some male programmers were refusing to pay us after we had put on a show in their venue. In our frustration, we spontaneously began beating a dirty rug in the backyard of Lewisham's ex-mortuary, screaming 'Beat the rug! Beat the patriarchy!' It was organic and cathartic. We then sent a strongly worded email and they coughed up.
11. When we came upon this quote when reading Little Women we were reminded of ourselves and our short sound and movement piece and thought 'wow, what a coincidence!'

FLOATING ORACLE 2 Wow, it's almost like Louisa May Alcott read our minds, or maybe we just read her book.

They all chuckle.

FLOATING ORACLE 2 Either way it confirms that Louisa isn't so different from us after all. In fact, the name Louisa contains a U and an S which spells...

 ALL Us.

FLOATING ORACLE 2 Or the U.S......which happens to be one of the biggest contributors to climate change.

FLOATING ORACLE 4 You may be tempted to think we have shoehorned the climate change topic into Little Women for no apparent reason. But we're not the only people who can see the clear link, because Greta Thunberg has made her own film adaptation of Little Women.[12] It came out Christmas 2019 starring Emma Watson and Soairse Ronan. We said, How Dare You, Greta.

FLOATING ORACLE 3 To which she replied, "Je ne re-Greta rien." And let's not forget-a that Louisa May Alcott was a climate change activist in her own special way, by being a vegetarian - very progressive for her day. However, she is ALSO the 4th cousin four times removed of George W. Bush, who beat his archnemesis, climate change fanatic, Al Gore in the 2000 US presidential election. So, unfortunately, her own descendants undid all her good work, destroying any hope for the future of our planet.

FLOATING ORACLE 5 You may also be wondering how much energy is required to freeze an ice sculpture every night, only to watch it melt under these fossil burning,[13]

12. We'd like to point out that we started making Little Wimmin before the new film was announced. We're pretty sure Greta copied us.
13. 'Do they mean fossil fuel?' we hear you ask. No. We really don't want you to think this a typo, it isn't. We actually did extensive research into fossil burning. Apparently it's an old Celtic ritual where the Elders of the Clan collect fossils that they would then burn to power their houses. It wasn't long until the Celts had realised how many shells it would take to power a follow spot. This was the inspiration behind the name of the

energy inefficient theatre lamps.

FLOATING ORACLE 1 And you may think that this is hypocritical in a show claiming to be about climate change...

Long pause.

FLOATING ORACLE 2 There will be a dance about renewable energy and single use plastic straws. It celebrates the power of AIRan ode to the wind turbine, the windmill and the humble fan. Yes, we did have to buy plastic straws, but they do make a very good point, and we do reuse them.

FLOATING ORACLE 1 In two hours from now, together we will make a cocktail. A margarita. Why? Because interestingly, in the 1949 movie adaptation the character of Beth was played by Margaret O'Brien which is English for Margarita.

FLOATING ORACLE 4 But there is another reason for the cocktail making. And it's not just because they are delicious!

FLOATING ORACLE 2 They are disgusting. They give me heartburn.

FLOATING ORACLE 4 Well, taste is subjective, Sarah. But what's objective is that all the objects required to make a delicious, classic, frozen Margaret are all found in the book Little Women by Louisa May Alcott.

FLOATING ORACLE 5 And when Rachel says "objects" what we mean is ingredients.

FLOATING ORACLE 3 Limes make an appearance in Chapter 7 'Amy's Valley of Humiliation'. For some reason, limes were the playground craze of the 1860s. Like an old fashioned yoyo, pog, or iPhone11. And so Amy collects a secret stash, in the hope that these key limes will allow her to poke her finger into the pie of popularity.

FLOATING ORACLE 4 Salt appears in Chapter 11 'Experiments', when the sisters host a dinner party. **FLOATING**

global energy company 'Shell'. Remarkable.

FO4 CONT. Unfortunately they have no culinary skills because their maid Hannah does everything for them. The climax of the chapter is when they serve strawberries that are covered in salt instead of sugar. Thrilling stuff.

FLOATING ORACLE 2 The character of Beth is based on Louisa May Alcott's sister, who died. Alcott wanted the novel to imitate true life and so was forced tequila off.

FLOATING ORACLE 1 But Cointreau to popular belief, Beth doesn't actually die in Little Women. She dies in the sequel, Good Vibes.

FLOATING ORACLE 5 And finally, as we've already explained, ice features heavily in Chapter 8. We will make the Margaret with the help of an industrial juicer. It represents the second industrial revolution of the late 1800's which saw the beginning of mass production, electricity and the advancement of

ALL Steel.

FLOATING ORACLE 3 Today machines do everything for us. We now stand, I mean float, on the brink of full automation. Soon theatres will be 3D printed and shows performed by holograms. Will they be any good? Who cares. We can go on holiday.

FLOATING ORACLE 2 Whilst we concoct the drink you will hear a liquid looping soundscape, mimicking the downward spiral of Capitalism. Capitalism is a modern day religion that worships money and gives the illusion of choice. But really it doesn't matter whether you buy your ice sculpture from Passion4Ice©, Funky Ice™ or IceIceBaby®, because they're actually all just made of *water*.

FLOATING ORACLE 4 Which brings us fluidly back to right here, right now, whenever now is. Because remember, time isn't real. We're above that. We are floating. With our heads in the clouds, we are floating in *air*... although later we will be standing on *earth*.

FLOATING ORACLE 1 Hang on. Water, Air, Earth... have

you guessed it? That's right, this show is on *(coughs)* Fire. And it's also about astrology, with each act symbolising a different element.

ALL Wow.

FLOATING ORACLE 2 That's right. For the last 200 years Jupiter and Saturn have conjuncted in Earth signs, which is why human society has been obsessed with Earth-based things, raw materials, coal, metal, fossil fuels, stripping the Earth of its natural resources,[14] like a hungry child sucking out the centre of a Cadbury's creme egg...or any brand of creme egg for that matter.

FLOATING ORACLE 3 But in December 2020, Jupiter and Saturn will begin a new cycle, conjuncting in Air signs. This will bring about new forms of communication, aviation, wind power, things our Earth-obsessed minds can't even imagine.

FLOATING ORACLE 4 Plus in January 2020, Saturn will also conjunct with Pluto. This will trigger the beginning of a new era which will see the dismantling of traditional power structures, equal distribution of wealth and the end of patriarchy.[15]

They all whimper in sarcastic pity.

FLOATING ORACLE 4 This is according to our astrologer... who we hired instead of an accent coach.[16]

14. Like John Smith and his mates in Pocahontas.
15. We'd like readers to bear in mind that we wrote and performed this show before the outbreak Covid-19. Now, as we edit this book, the UK is in lockdown. Us Figs haven't hung out in person for weeks. You could say that power structures are dismantling, that the government is redistributing money to the public, and patriarchs such as Boris Johnson aka BJ, have been struck down with the virus. McDonalds, Starbucks, and other tasty but nasty companies have been forced to close. Our society is realising the importance of its key workers; its doctors, nurses, teachers and bus drivers...hang on...doesn't this sound like...THE BEGINNING OF A NEW ERA?!?!?! Maybe you're reading this book in the future, which is now (remember time is a construct), Covid 19 is a thing of the past and the new era is the NOW era. And maybe you're thinking, "Fuck, Figs in Wigs were right. Astrology isn't bullshit".
16. This is true. Her name is Madeleine Botet de Lacaze and she's

FLOATING ORACLE 2 And again you may think we have shoehorned astrology into Little Women. But remember that Chapter 8 was called 'Jo Meets Apollyon'! Well, Apollyon, who also appears in Bunyan's book, just happens to be part dragon, bear, human, and fish, uniting all four elements.[17]

ALL Wowee!!!!!

FLOATING ORACLE 1 But maybe you think that astrology is bullshit. Or maybe you think that climate change is bullshit. Or maybe you think that climate change is just being accelerated by bull's shit.... and farts. Either way we are representing the new era of Air signs, by being floaters.

FLOATING ORACLE 5 Yes, we'd like to emphasise that we're floating not flying. Flying is expensive and it turns out it's very bad for the environment according to Greta Gerwig.

FLOATING ORACLE 4 And finally, not that we want to overload you with information, but a different reading of this particular scene is that we are actually the fifth element. And that's why there's five of us.

Music cuts. Pause.

FLOATING ORACLE 3 Any questions?

The front lights snap off. The **FLOATING ORACLES** *remain suspended in the air, backlit as the curtain comes down. The house lights come up on the auditorium. A non-male voice speaks the following:*

VOICEOVER There will now be a 20 minute interval whilst Figs in Wigs get off their high horses. The bar is open, why not try a delicious Margaret?[18]

incredible. She is a Libra so she gives us balance.
17. Our dramaturg Urusla Martinez discovered this information about Apollyon when she got into a Wikipedia research wormhole whilst she was helping us edit the script.
18. This voiceover is actually spoken live by our Technical Octopus Sorcha Stott-Strzala, thus called because she is required to press, poke, and pull many things at once.

An interval [19]

During the 20 minute interval the following music is played. Each song played represents the topics and elements we were covering in the previous scene.

Playlist: [20]

> *Carole King- I Feel the Earth Move*
> *Ann Pebbles - I Can't Stand The Rain*
> *Madonna - Burning Up*
> *Shocking Blue - Venus*
> *TLC - Waterfalls*
> *Pat Benatar - Fire and Ice*

19. An early idea for the interval was that when the audience left the auditorium they would be met by us, Figs in Wigs, working behind the bar, and we would nonchalantly serve them packets of crisps and drinks. But it turns out clearing the stage of five steel floating-apparatuses and a massive white backdrop, followed by setting the next scene and changing from slankets to poplins is actually quite time consuming and Sorcha (our Technical Octopus) needed our help. So this idea was sadly scrapped.

20. Feel free to take an interval yourself. For an authentic experience why not make yourself a frozen Margaret and listen to the songs.

Act 2

BETH DIES

BETH DIES

BETH DIES

BETH DIES

BETH DIES

BETH DIES

BETH DIES

BETH DIES

BETH DIES

BETH DIES

BETH DIES

BETH DIES

BETH DIES

BETH DIES

BETH DIES

BETH DIES

BETH DIES

BETH DIES

BETH DIES

BETH DIES

BETH DIES

BETH DIES

BETH DIES

BETH DIES

BETH DIES

BETH DIES

BETH DIES

BETH DIES

BETH DIES

BETH DIES

BETH DIES

BETH DIES

scene one
Playing pilgrims

The curtain rises to reveal a 19th century period living room. It is very much a theatre set. The furniture, walls and props are all in different hues of orange. An orange wall provides the backdrop to the scene which is framed with orange stage curtains either side and an orange pelmet above. There is a fireplace painted stage right on the wall, within which a painted fire roars. A crudely painted portrait of the sisters dressed in orange dresses hangs above the fireplace. In front of the fireplace is an orange chaise longue, an orange poof and a wooden chair with an orange cushion. A carpet beater rests against the orange wall behind the chair. In front of the seating area is an orange floral patterned rug, on which there is a ball of orange knitting and a pair of orange slippers. On stage left of the wall there is a door, leading to the outside world. Downstage of the door there is a table, covered with an orange, lace tablecloth, upon which there is a lit orange candle. The candle is the only light on stage. The only non-orange thing, a green Christmas tree made from crepe paper, stands against the wall in between the fireplace and the door.

*Suddenly death metal music plays (Sit Stay Roll Over by Jinger) and the words "BETH DIES" flash on the pelmet above the living room whilst lights strobe. The four Little Wimmin enter, **JO** and **BETH** from stage right and **MEG** and **AMY** from stage left, walking purposefully towards the seating area oblivious of the death metal. As soon as they are in position the music stops and the lights snap to the warm orange glow of the March family living room. **MEG** is sitting on the chaise longue, **BETH** on the chair, **AMY** and **JO** are lounging on the rug. Unbeknownst to the audience, Suzanna, the fifth performer, is also on stage because she is the **CHRISTMAS TREE**. The next scenes are all spoken in the performers' best American accents, which are not entirely convincing.*

JO Christmas won't be Christmas without any presents.

MEG Oh it's so dreadful to be poor!

AMY I don't think it's fair for some girls to have plenty of pretty things, and other girls nothing at all.

BETH We've got Father and Mother, and each other.

JO *(solemn)* We haven't got Father.

The sisters all lower their eyes in sadness.

JO And we shall not have him for a long time.

MEG You know the reason Marmee proposed not having any presents this Christmas? Well it's because it is going to be a hard winter for everyone; and she thinks we ought not to spend money for pleasure, when our men are suffering so in the army. We can't do much here, but we can make our little sacrifices, and ought to do it gladly. But I am afraid I don't.

AMY *joins* **MEG** *on the chaise longue.*

JO But I don't think the little we should spend would do any good. We've each got a dollar, and the army wouldn't be much helped by our giving that. I agree not to expect anything from Marmee or you girls, but I do want to buy a book for myself.

BETH I would like some new sheet music for my piano.

AMY I shall get a nice box of Faber's drawing pencils; I really need them.

MEG I had wanted a nice pair of gloves.

JO Mother didn't say anything about our money, and she won't wish us to give up everything. *(Suddenly excited)* let's each buy what we want, and have a little fun; I'm sure we work hard enough to earn it!

MEG I know I do! Teaching those tiresome King children all day, when I'm longing to enjoy myself at home.

JO You don't have half such a hard time as I do. How would you like to be shut up for hours with a nervous, fussy

old lady, like Aunt March, who keeps you trotting, is never satisfied, and worries you till you're ready to fly out the window or cry?

They all giggle.

BETH It's naughty to fret, but I do think washing dishes and keeping things tidy is the worst work in the world. It makes me cross, and my hands get so stiff, I can't practise well at all! *(Mimics playing piano stiffly.)*

AMY *(stealing the limelight)* I don't believe any of you suffer as I do, for you don't have to go to school with impertinent girls, who plague you if you don't know your lessons, and laugh at your dresses, and label your father if he isn't rich, and insult you when your nose isn't nice *(points to her nose and attempts to look at it).*

JO *(laughing)* If you mean libel, I'd say so, and not talk about labels, as if Papa was a pickle bottle.

AMY I know what I mean, and you needn't be so statirical about it. It's proper to use good words, and improve your vocabilary.

AMY *storms over to the chair, causing* **BETH** *to jump up out of it.*

MEG Don't peck at one another, children. Don't you wish we had the money Papa lost when we were little, Jo? Dear me! How happy and good we'd be, if we had no worries!

BETH You said the other day you thought we were a great deal happier than the King children, for they were fretting and fighting all the time, in spite of their money.

MEG So I did, Beth. Well, I think we are. For though we do have to work, we make fun of ourselves, and are a pretty jolly set, as Jo would say.

AMY Jo does use such slang words!

JO *saunters nonchalantly across the stage, her hands behind her back, and begins to whistle.* **AMY**, *horrified at the sound, rushes over to* **JO**.

AMY Don't, Jo. It's so boyish!

JO That's why I do it.

AMY I detest rude, unladylike girls!

JO I hate affected, niminy-piminy chits![21]

JO *and* **AMY** *now stand aggressively close.* **BETH** *jumps up and goes between them.*

BETH Sisters, sisters, sisters! *(Singing with a funny face.)* Birds in their little nests agree!

Both **AMY** *and* **JO's** *harsh voices soften to laughs and the "pecking" ends.* **BETH** *returns to the chair.*

MEG Really, girls, you are both to be blamed. You are old enough to leave off boyish tricks, and to behave better Josephine. It didn't matter so much when you were a little girl, but now you are so tall, and turn up your hair, you ought to remember that you are a young lady.

JO I'm not!

The others gasp in horrified unison.

JO And if turning up my hair makes me one, I'll wear it in two tails till I'm twenty! *(She pulls pins out of her hair so that it falls down in plaits.)*

During **JO's** *following speech* **AMY** *takes the pins from* **JO** *and rushes back to sit beside* **MEG** *on the chaise longue, handing her the pins.* **MEG** *puts the pins in* **AMY's** *hair.* **BETH** *listens intently.*

JO I hate to think I've got to grow up, and be Miss March, and wear long gowns, and look as prim as a china doll! It's bad enough to be a girl anyway, when I like boy's games and work

21. That's right 'chit', rhymes with shit. 'Chit' is a dismissive term for a girl who is immature or who lacks respect; "she was incensed that this chit of a girl should dare to make a fool of her in front of the class"; "she's a saucy chit"

and manners! I can't get over my disappointment in not being a boy. And it's worse than ever now, for I'm dying to go and fight with Papa, and I can only stay home and knit, like a poky old woman!

JO plods back to the rug and sits down despairingly, her large skirt ballooning around her.

BETH Poor Jo! It's too bad, but it can't be helped. So you must try to be contented with making your name boyish, and playing brother to us girls.

MEG *(to AMY)* As for you, Amy you are altogether too particular and prim. Your airs are funny now, but you'll grow up an affected little goose, if you don't take care. I like your nice manners and refined ways of speaking, when you don't try to be elegant. But your absurd words are...well, they are as bad as Jo's slang!

BETH If Jo is a tomboy and Amy a goose, what am I, please?

BETH reaches out her hands and MEG takes them.

MEG *(warmly)* You're a dear, and nothing else.[22]

Pause.

AMY Marmee shall be home soon.

ALL Marmee!

BETH I shall warm her slippers by the fire! *(She goes to kneel by the slippers.)*

22. If you were lucky enough to watch a work-in-progress of this show, you will of course remember that we started this scene by doing our best Massachusetts accent (which is average), before sliding into a Deep South drawl, moving over to Brooklyn, New York, then back to Massachusetts, finishing off with Australian. Even though we have got rid of the changing accents we all still have lines that we struggle not to say in their "original" way. This line was in Australian and Gammon still struggles to say it without sounding like Susan Kennedy from Australia's comforting yet never-ending soap Neighbours or Mr G from Summer Heights High.

JO They are quite worn out. Marmee must have a new pair.

BETH I thought I'd get her some with my dollar.

AMY No, I shall!

MEG I'm the oldest!

JO I'm the man of the family now Papa is away, and I shall provide the slippers, for he told me to take special care of Mother while he was gone.

AMY Eww.

BETH I'll tell you what we'll do, let's each get something for Marmee and not get anything for ourselves.

JO That's like you, dear! What will we get?

BETH *places the slippers by the fire.*

MEG I shall give her a nice pair of gloves.

JO Army shoes, best to be had.

BETH Some handkerchiefs, all hemmed.

AMY I'll get a little bottle of cologne. She likes it, and it won't cost much, so I'll have some left to buy my pencils.[23]

MEG How will we give the things?

JO Put them by the tree, and bring her in and see her open the bundles. Don't you remember how we used to do on our birthdays?

MEG Yes I do, Jo. Oh what a wonderful surprise it will be! Now come girls we have much to do before the morrow.

23. This line was originally said in a New York accent. Sarah still struggles to say it without sounding like Joey Tribbiani's agent Estelle.

They gather around **MEG** *somewhat awkwardly, their arms around each other, staring earnestly into the distance.* **BETH** *is carrying the candle. A pause. She blows out the flame.*

Blackout.

Incidental music.

scene two
A merry christmas

The March family living room. Morning.

AMY is dancing around jollily and BETH is sitting on the floor by the CHRISTMAS TREE. On the dining table a spread of orange toned foods: a lobster, a ham, small pumpkins, carrots and clementines, a jar of orange jam and an orange jelly. There is also a small orange wicker basket and a letter addressed to the sisters.

AMY *(calling offstage)* Meg! Jo! Are you awake? Oh do come and see! Mother has left us each a present under the tree!

JO and MEG enter stage right. AMY drags them towards the CHRISTMAS TREE.

JO And a Merry Christmas to you too Amy!

BETH *(hugging them in turn)* Merry Christmas Jo! And Meg!

MEG Merry Christmas my dears! *(Gathering BETH and AMY in her arms.)*

AMY *(breaking away)* But the presents!

They unwrap their presents: a copy of Eat, Pray, Love by Elizabeth Gilbert

AMY Aren't they wonderful?

JO They most certainly are. The same beautiful old story of the best lives ever lived, and a true guidebook for any pilgrim going on a long journey.

MEG Girls, Mother wants us to read, pray and love and mind these books, and we must begin at once. We used to be faithful about it, but since Father went away and all this war

trouble unsettled us, we have neglected many things. You can do as you please, but I shall keep my book on the mantle here and read a little every morning as soon as I wake, for I know it will do me good and help me through the day.

MEG *places her book on the mantelpiece painted onto the set wall. It falls to the floor. They do not react.*

BETH Oh yes! Let's all do the same. Amy, I'll help you with the hard words.

AMY But must we read them now? I'm starved.

JO Christopher Columbus! What a fine feast our maid Hannah has prepared!

The sisters all flock around the table.

MEG Oh how I adore Christmas breakfast! It reminds me of when we weren't so goddam poor. Mmmmmmmm muffs! *(Stuffs some food in her mouth.)*

BETH Oh how I like to have breakfast with you my dear sisters, for every day is like Christmas with you.

BETH *picks up the jelly (jello) starts to sing. The others join in along the way.*

> Jello is jelly
> And jelly is jam
> But what is jambon?
> It's ham.

End of song.

BETH Oh look a letter...*(picking up the letter)* from Marmee!

ALL *(lovingly, hands on hearts)* **Marmeeee!!**

BETH Read it Jo. *(She hands the letter to **JO**)*

*Whilst **JO** reads, **MEG**, **BETH** and **AMY** graze on the orange foods.*

JO (reading aloud) 'Merry Christmas, little daughters! I am sorry to not see your bright faces this morning as you opened your parcels. I do hope you will enjoy reading your guide books. I have gone with Hannah to visit Mrs Hummel - a poor woman, not far from here, with six children and a little newborn baby all huddled into one bed to keep from freezing.'

AMY Eww.

BETH looks saddened and **MEG** looks down guiltily at the clementine she has peeled in her hand.

JO (continuing to read) 'They have no fire and nothing to eat, and the oldest boy came to tell me they were suffering from hunger and cold. My girls, will you give them your breakfast as a Christmas present?'

A silence as they contemplate their hungry bellies. There is the sound of a stomach rumbling.

MEG takes a deep breath and re-wraps the clementine she is holding and places it back on the platter. **AMY** puts the whole clementine she has peeled into her mouth.

MEG Come girls, this is our first test. From our guidebooks. I shall carry the lobster (Throws a knowing look at the audience.) [24]

AMY quickly sticks her fingers into the jar and scoops a pawful of jam into her mouth.

BETH Alright. May I take the jello?

AMY I shall take the... fruit!

JO And I the ham! Is everyone sufficiently laden? Then march on my March sisters.

They exit with breakfast. Incidental music. Blackout.

24. Meg, played by Rachel Gammon also played Floating Oracle 1, who earlier remarked on the remarkable lobster history of Massachusetts.

scene three
Roll around the udders, carpet beating and other stories

Lights up on the March family living room. Afternoon. The dining table is once again laden with orange food.

MEG, **JO**, **BETH** and **AMY** *(offstage, singing)*

> Now, bring us some figgy pudding,
> Now, bring us some figgy pudding,
> Now, bring us some figgy pudding,
> and bring it out here!
>
> And we won't go until we got some,
> and we won't go until we got some,
> and we won't go until we got some,
> so bring some out here!

*Enter **JO**, **MEG**, **AMY** and **BETH** through the door of the house laughing gleefully.*

MEG Now that's loving our neighbour better than ourselves, and I like it!

BETH Oh look! A letter!

BETH *picks up the letter. She wanders to her chair, opens it and begins to read quietly to herself. The others notice all the food is now back on the dining table. They gasp at the sight and rush to it.*

JO Christopher Columbus! Another feast!?

AMY Is it fairies or Santa Claus?

MEG Our maid Hannah did it! But where would a servant get the money...?

JO Aunt March must have sent it!

BETH *(looking up from letter)* All wrong. Old Mr. Laurence sent it!

AMY You mean the scary, rich, old man who lives with his grandson in the big house next door? He is an odd, old gentleman...

AMY, **MEG** and **JO** *gather downstage left looking out to the middle distance, as if peering through their window at the neighbour's house.*

MEG What in the world put such a thing into his head? We don't even know him!

BETH *(hearts in eyes)* It says here that our maid Hannah told one of his servants about our charitable breakfast party and it pleased him so. And so, he wanted us to have a little 'afternoon delight' to make up for giving up our breakfast.

JO I bet his grandson put it into his head, I know he did! He looks like a capital fellow, and I wish we could get acquainted. I often see him looking down at us from his window, he'd like to know us but he's bashful, and Meg is so prim she won't let me speak to him when we pass.

MEG *(primly)* I like his manners, and he looks like a little gentleman, so I've no objection to your knowing him, if a proper opportunity comes along.

BETH *(standing up from her chair)* Well here's one. He has invited us to a ball at his house! Tonight!

MEG Tonight?!

They all run to **BETH**. **MEG** *snatches the letter from* **BETH's** *hand.*

AMY All of us?

BETH All of us!

MEG *(horrified)* Oh heavens, what shall we wear?

JO *(at the table, mouth full)* What's the use of asking that, when you know we shall wear our poplins, because we haven't got anything else?

MEG If I only had a silk! Mother says I may when I'm eighteen perhaps, but two years is such a devastatingly long time to wait. *(Sinking dejectedly onto the chaise longue.)*

BETH *(consoling)* I'm sure our poplins look like silk, and they are nice enough for us.

JO Yours is as good as new, but I forgot the burn and the tear in mine. Whatever shall I do? The burn shows badly.

JO turns to show the back of her skirt and the burn mark to the room. The others gasp.

MEG swivels JO back around, examining her dress.

MEG The front is all right. You must sit still all you can and keep your backside against the wall. *(She pushes JO down into the chair with a little too much force, a glazed look in her eyes.)* I shall have a new ribbon for my hair, and Marmee will lend me her little pearl pin, and my new slippers are lovely, and my gloves will do, though they aren't as nice as I'd like.

JO Mine are spoiled with lemonade, and I can't get any new ones, so I shall have to go without.

AMY *(shouting in JO's face)* You must wear gloves, or I won't go!

MEG *(seriously)* Gloves are more important than anything else. You can't dance without them, and if you did I should be so mortified.

JO Then I'll stay still. I don't care much for company dancing. It's no fun to go sailing round. *(She sways slowly, arms out, miming dancing)* I like to gallop about and cut capers. *(Picking up speed and galloping around the room.)* Oh boy, I wish I were a horse!

BETH *(rushing to* **JO** *to stop her)* Oh Jo, don't be a bother. Can't you make them do?

JO *(shrugging)* I can hold them crumpled up in my hand, so no one will know how stained they are. That's the best I can do.

MEG No, I'll tell you how we will manage. We'll each wear a good one and carry a bad one. *(She joins* **JO** *downstage and takes her hand.)* Though your hands are bigger than mine, and you will stretch my glove dreadfully. *(Placing their hands palm to palm up to compare sizes.)* Only don't stain it, and do behave nicely.

Pained, **MEG** *moves to the table and picks at the food.* **BETH** *follows.*

AMY *(bossily)* When we are there, don't put your hands behind you, or stare, or say 'Christopher Columbus!' will you?

JO If you see me doing anything wrong, just remind me with a wink.

MEG No, winking isn't ladylike. I'll lift my eyebrows if anything is wrong, and nod if you are all right. Now hold your shoulders straight, and take short steps, and don't shake hands if you are introduced to anyone. It isn't the thing.

JO Don't worry about me. I'll be as prim as I can and not get into any scrapes, if I can help it.

MEG *(hugging* **JO***)* Thank you Jo! Come girls, let's tidy up this mess before Marmee returns.

They move around the room, clearing the Christmas debris. **MEG** *places the books on the 'mantelpiece',* **JO** *collects the fabric wrapping paper,* **BETH** *picks up the ribbons,* **AMY** *picks up the wool and licks the jam. As they tidy they naturally start humming and then singing this song:*

ALL Roll around the udders girls,
Roll around the udders,
Roll around the udders girls,

Roll around the udders.

Take your udders and take 'em down
Take 'em down to the bottom of town
Roll around the udders girls,
Roll around the udders.[25]

MEG This rug is so dusty. Sisters, will you help me beat it?
(Picking up the carpet beater.)

They each pick up a corner of the rug. **MEG** *uses the carpet beater, the others beat with their hands. Whilst beating the rug they begin chanting. Softly and jovial at first before gradually building into a raging frenzy. The lighting changes from the warmth of the living room to a dark, deep red. Large shadows of the possessed sisters are cast on the backdrop. It's like hell, or Plato's cave... or the patriarchy.)*

ALL Beat,
Beat,

Beat,

Beat,

Beat,

Beat,

25. This is a song we wrote in 2015 when on tour with our award-losing show Show Off. In the show, one of the costumes we wear is five matching cow outfits complete with felt ears and rubber udders. On tour the udders were taking a bit of a bashing in transit; when folded into a suitcase, the cheap rubber would tear, giving the appearance of cracked nipples or teats. Rachel Gammon (head of wardrobe) cleverly instructed the rest of us to roll the cow material around the udders when packing them, rather than folding the udders themselves. 'Roll around the udders girls,' she would say to us. 'Roll around the udders', we would affirm back. The song began organically as an aural reminder for our task, and we would sing as we rolled. The tone of the song is very mournful and has the feeling of a long lost folk song passed down from generation to generation. See page 84 for the musical score and you can sing along yourself. Sarah originally found the song too sad to listen to, but now she is able to sing along happily.

Beat,
Beat,
Beat,
Beat,

Beat,

Beat,
Beat the rug,

Beat,

Beat,
Beat,

Beat the rug,

Beat,

Beat,
Beat the rug,

BEAT

BEAT,

BEAT THE RUG,
BEAT
THE,
RUG,
BEAT,

THE,

RUG,
BEAT,
THE,
RUG,

BEAT,
THE,
RUG,
BEAT
THE
PATRIARCHY!
BEAT,
THE,
RUG,
BEAT
THE
PATRIARCHY!
BEAT,
THE,
PATRIARCHY!
RUG,
BEAT
THE
PATRIARCHY!
BEAT,
THE,
PATRIARCHY!
RUG,
BEAT
THE
PATRIARCHY!
BEAT,
THE,
PATRIARCHY!
RUG,
BEAT *beat the rug,*
THE
PATRIARCHY!
BEAT THE RUG
BEAT THE RUG

45

BEAT,
THE,
RUG,
BEAT,
THE,
patriarchy!
BEAT,
THE
RUG,
BEAT THE
PATRIARCHY!
BEAT THE RUG,

PATRIARCHY[26]

26. We originally wanted to include all the male characters from the book in our adaptation, with each one being objectified in the form of a different domestic prop. For example, Mr Davies, Amy's teacher, was going to be played by a carpet beater. In Chapter 7, Amy's Valley of Humiliation, Mr Davies canes Amy in front of the whole school for having limes in her desk. How humiliating. We planned to avenge Amy's humiliation by inviting all of the men in the room up onto the stage and spanking each of them in turn using Mr Davies, aka the carpet beater. However we realised that audiences don't particularly like audience participation and neither do we. So instead we decided to do this innovative performance poem.

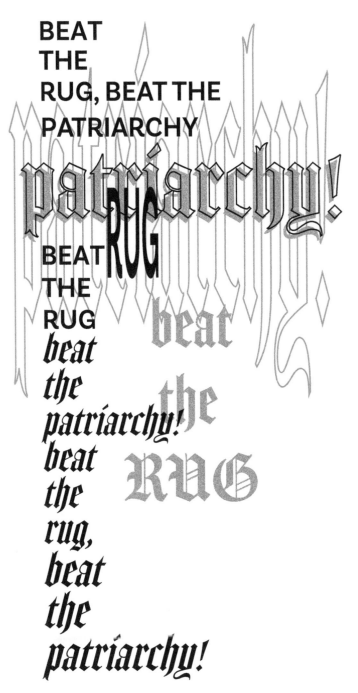

BEAT
THE
RUG, BEAT THE
PATRIARCHY

patriarchy!
RUG

BEAT
THE
RUG
beat
the
patriarchy!
beat
the
rug,
beat
the
patriarchy!

beat
the
RUG

beat the rug, beat, pattis

the crch–

BETH *(Interrupting the chanting)* Oh look! A letter!

The lights snap back to a naturalistic state. They stop beating the rug. **BETH** *picks up the letter from under the rug.*

BETH From Father!

ALL *(slightly awkward after the condemning of his gang)* Father!

BETH Read it, Meg.

Somewhat exhausted, they all make their way to the seating area. **MEG** *sits upstage on the chaise longue with* **AMY** *seated next to her on the right.* **JO** *stands behind them and* **BETH** *perches on the poof at* **MEG's** *feet, handing her the letter. As* **MEG** *reads the letter the sisters react with whimpering sniffles.*

MEG *(reading and weeping)* 'My darling girls, I send you all of my dear love and a kiss. I think of you by day, pray for you by night, and find my best comfort in your affection at all times. A year seems very long to wait before I see you all, blah **blah** blah blah blah blah blah blah blah blah **blah** blah blah blah blah blah blah blah blah blah blah **blah** blah **blah** blah blah blah blah blah blah blah blah blah blah blah blah blah, my Little Wimmin.[27]

The sound of rain. They start to properly cry. The more upset they become, the louder the rain. The louder the rain, the louder they cry until they are all hysterically wailing uncontrollably. Ugly crying with snorts, snot and drool. Gradually they calm back down to sniffling whimpers.[28]

27. Fans of the book will know that this letter is in fact read by Marmee to her daughters. In an earlier version of this show Marmee was played by Rachel Gammon and Meg by Suzanna (back when Suzanna was still in the "traditional" part of the show, long before she had admitted to her complete hatred for the book). Marmee's entrance included a queen's lift where the sisters carried her from the door to her armchair. Marmee then pulled a microphone out of her handbag and began to read the letter in a 'voice of god' style. We once performed this version to a bewildered audience at Pulse Festival, Ipswich 2018. Unfortunately when the role of Marmee was axed so was her entrance. It was a sad day when we had to throw this scene onto the editing suite floor.
28. At one point we were going to project PATHETIC FALLACY above the distraught sisters, whilst they sob to the soundtrack of rain. But we never

BETH It feels like this pain will never end. I know we are not out of the woods yet but when will it be over?

AMY I don't think anybody knows.

MEG I fear it may be some time. Now take my hands dear sisters and try to remember that we are not the only ones who are suffering.

JO Hey, many people have witnessed a scene just like this before and so will many people after them. There is nothing we or they can do to stop it. All we can do is remain strong and stable until the end is nigh.

They sniff and whimper a little more before freezing in a classic Little Women tableau. It is still raining, but it has eased off slightly.

Slow fade up of a green spotlight on the **CHRISTMAS TREE,** *which turns around, to reveal Suzanna, inside it. She has been there all along, wearing a Christmas tree for a dress, a star topped hat and wrapped presents for shoes. She now performs the role of* **CHRISTMAS TREE** *in a sassy, valley girl accent.*[29]

CHRISTMAS TREE Merry Christmas :(

This will be my first Christmas away from home. It'll also be my last Christmas. I'll be thrown out in January.

It's not so bad, I could have been turned into pulp, or even worse pulp fiction. Good trees die for shit books all the time. It's a waste. I thought I'd lucked out by becoming a Christmas tree but instead I've been palmed off with this arbitree role of a Christmas tree in a shitty theatre adaptation of a shitty book that I'm forced to listen to every night. I've been standing here for so long I've got pins and needles.

did that in the end...

29. We once flirted with the idea of Suzanna as the Christmas Tree putting the March sisters under a citizen's arrest. This was inspired by the leaked footage of Fergus Beely's failed attempt to put a motorist and their entire family under a citizen's arrest. Our favourite line from the clip is: "Put your hands on the car and prepare to die!"

Look
at them,
tableauing.
At least they've
shut up for a bit,
the acting is so wooden.
And the choice! Branch out
- Little Women is acorn-y piece
of crap. Louisa May Alcott didn't even
want to write this book. She wanted to
write hard boiled crime with graphic violence
and punchy dialogue. But her publishers wouldn't
leaf her alone and forced her to write this sappy mulch.

She hated it. She called
it 'moral pap for the young'
And I can see why. It's fucking
boring. But it was poplar with the
fans - they must have been barking mad!
I'm pining after my old life, I could've really
blossomed there. I'd give anything to escape this
hell. If I could have one Christmas wish it would be for
all of this to be over. But we're not out of the woods yet.

Classical music strikes up (Jacques Offenbach's L'île de Tulipatan) and the entire set revolves 180 degrees clockwise. The sour faced **CHRISTMAS TREE** *and the four 'tableauing' sisters are spun away revealing a glitzy, sparkly, dark blue set on the other side of the wall.*

𝕿scene four
𝕿he ball
(or meg's hen part𝖄)

The classical music continues to play. One by one **AMY**, **BETH**, **JO** and **MEG** enter through the door, which is now on stage right as the set has revolved. They are all wearing orange evening gloves. **JO** and **MEG** are wearing one 'good' glove each and holding the 'bad' ones.

They move down stage and position themselves in an isosceles trapezoid formation. They curtsy a few times to the audience and to each other. The melody kicks in and they begin a carefully choreographed dance, all in sync with each other.[30] In the middle section of the dance JO, **BETH** and **AMY** exit leaving **MEG** contemporary

30. An old version of this dance would incorporate Laurie (played by a ladder) dancing with Jo. However, he kept forgetting the steps so we decided to do the dance without him.

dancing by herself and pretending to be wooed by an imaginary suitor. **JO, BETH** and **AMY** re-enter pushing a stainless steel trolley which holds a vodka luge shaped like a giant penis.[31] They are all wearing hen party sashes: **JO's** says 'Best Man', **AMY's** says 'Maid of Honour' and **BETH's** says 'Beth Dies.' **AMY** gives one to **MEG** which says 'Bride to Be'. They each drink a shot of vodka from the penis luge before pushing it down stage right.[32]

They resume dancing. Now they are drunk and their movements are much more wild and ungainly. The dance culminates in some less than perfect floor work and with a flourish they throw their arms in the air. The music ends and they laugh and clutch each other in drunken ecstasy. The revolve begins to spin as they walk towards home.

31. A vodka luge is an ice sculpture with a hole drilled through it allowing you to pour vodka through the hole at the top ready to be caught at the bottom in a cup or an open mouth. The luge is the perfect ice-breaker and a must-have party necessity.

32. Where the projection had read PATHETIC FALLACY (see footnote 28), it would now change to PATHETIC PHALLUSY. But again, we never did this...

scene five
Naturalistic destiny
part one

The revolve turns 180 degrees clockwise to reveal the March family's orange living room. Late morning. It is still raining and there is a storm brewing. The **CHRISTMAS TREE** *is no longer there.* **JO**, **AMY**, **BETH** *and* **MEG** *enter one by one through the door. They are hung over, sweaty and sick. They stagger slowly back to the seating area, discarding sashes and gloves along the way. They settle once more in the same positions,* **MEG** *and* **AMY** *on the chaise longue,* **JO** *standing behind and* **BETH** *on the poof. The next lines are spoken with difficulty due to their severe hangovers.*

BETH It feels like this pain will never end. I know we are not out of the woods yet but when will it be over?

AMY I don't think anybody knows.

MEG I fear it may be some time. Now take my hands dear sisters and try to remember that we are not the only ones who are suffering.

JO Hey, many people have witnessed a scene just like this before and so will many people after them. There is nothing we or they can do to stop it. All we can do is remain strong and stable until the end is nigh.[33]

33. Deja vu? That's right we've been here before. On page 51. We call this the Genius Text, so called because before we had written the text we knew it had to be 'genius', and when we say 'genius' what we mean is the words take on a new meaning each time they are repeated. Here, the emotional pain of the absence of Father transforms into the physical pain of the day after drinking ten shots of vodka. Genius.

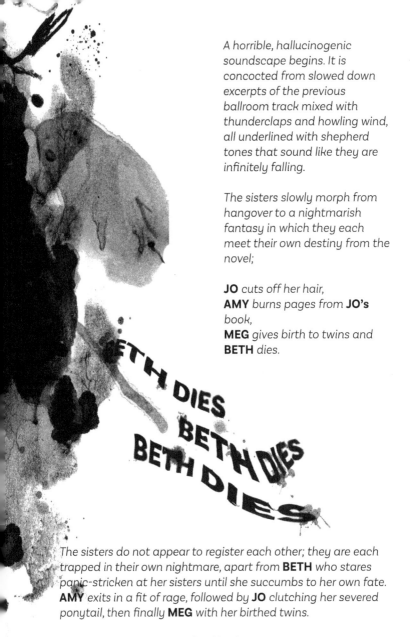

A horrible, hallucinogenic soundscape begins. It is concocted from slowed down excerpts of the previous ballroom track mixed with thunderclaps and howling wind, all underlined with shepherd tones that sound like they are infinitely falling.

The sisters slowly morph from hangover to a nightmarish fantasy in which they each meet their own destiny from the novel;

JO cuts off her hair,
AMY burns pages from JO's book,
MEG gives birth to twins and BETH dies.

The sisters do not appear to register each other; they are each trapped in their own nightmare, apart from BETH who stares panic-stricken at her sisters until she succumbs to her own fate. AMY exits in a fit of rage, followed by JO clutching her severed ponytail, then finally MEG with her birthed twins.

Curtain down on BETH's dead body.

All that is left of the nightmarish soundscape is the sound of a swirling snow storm.

scene six
Driving home for naturalistic destiny part two

Suddenly the music snaps to the beginning of Driving Home for Christmas by Chris Rea. **CHRISTMAS TREE** *enters in front of the curtain holding a microphone. Lit by a follow spot, she begins to lip sync to the song.*

On the line 'And it's been so long…' the curtain rises to reveal the glitzy side of the set as **MEG**, **JO**, **BETH** *and* **AMY** *enter as strange 'mascots' that each represent their own burdens;* **BETH** *is a* **MUCUS SACK**, **AMY** *is a giant* **NOSE**, **MEG** *is a giant lace* **GLOVE** *and* **JO** *is a* **HORSE** *- or rather half-horse/half-boy, a reverse centaur (Louisa May Alcott was a Sagittarius and based Jo on herself); she is wearing a rubber horse head, a brown pinstripe suit and a strap-on harness worn backwards with her own ponytail that she just cut off in the previous scene coming out of her backside like a… pony's tail.*

They step ball change in unison into formation with **CHRISTMAS TREE**. *On the line 'Driving home for Christmas' they all begin a showtime dance with lots of footwork, leg kicks, stomps and grapevines.* **CHRISTMAS TREE** *is lip syncing to the song the whole time, with the four mascots as her backing dancers. It's reminiscent of old Saturday night telly and also the Teletubbies.*

At the end of the song the music begins to skip and loop on the lyrics: 'driving home, driving home, driving home, driving home…'

They all get into a mimed 'car' formation, **CHRISTMAS TREE** *is in the driving seat,* **MUCUS SACK** *is riding shotgun,* **NOSE** *and* **HORSE** *are in the backseat and* **GLOVE** *is in the boot like a dog (it's an estate car, room for all the family).* **CHRISTMAS TREE** *uses the microphone as a gear stick and they 'drive off' (the revolve begins to turn)…*

The end of the song loops and spirals into a psychotropic,

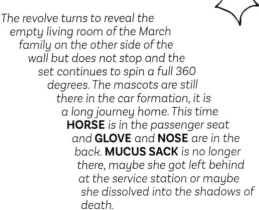

*softcore sonic purgatory with those
pesky shepherd tones once again
rearing their anxiety-inducing heads.
Every now and then remnants of
Chris Rea's wailing can be heard, as
if from the depths of the underworld,
"Sooo long...." "Christmassss, yeah...."*

*The revolve turns to reveal the
empty living room of the March
family on the other side of the
wall but does not stop and the
set continues to spin a full 360
degrees. The mascots are still
there in the car formation, it is
a long journey home. This time
HORSE is in the passenger seat
and **GLOVE** and **NOSE** are in the
back. **MUCUS SACK** is no longer
there, maybe she got left behind
at the service station or maybe
she dissolved into the shadows of
death.*

*The set does not stop rotating
round and round, alternating
between the mascots on the
glitzy side and the empty living
room on the other. As it spins
the mascots perform a series
of tableaux demonstrating their
destinies; **NOSE** has smoke
coming out her nostrils, **HORSE**
cuts off her tail, **GLOVE** gives birth
to not one, but two small gloves
and **CHRISTMAS TREE** brandishes
an axe and begins to chop wood in a
quasi-suicide attempt.*

*On the second to last rotation **BETH**
is back in the living room, sitting on
her favourite chair and smiling. A
ghost of the past frozen in time.*

*The music then morphs into a trippy,
Sonic-the-Hedgehog-esque like
soundtrack. The mascots are dancing
along on the glitzy side. The world
keeps turning...*

An unsettling, drone-like sound.

The revolve finally stops in the empty living room. **BETH** *is gone, and the picture on the wall has changed from a portrait of the four sisters to a portrait of* **NOSE**, **HORSE**, **GLOVE** *and* **CHRISTMAS TREE**.

The **NOSE**, **HORSE**, **GLOVE** *and* **CHRISTMAS TREE** *enter through the front door. They struggle getting through due to their enormous costumes.*

They return to their positions in the living room and sit down (with some difficulty). This time **CHRISTMAS TREE** *has replaced BETH.*

TREE It feels like this pain will never end. I know we're not out of the (WOODS) yet, but when will it be over?

NOSE I don't think anybody (NOSE!)

GLOVE I fear it may be some time. Now take my (HANDS) dear sisters and try to remember that we are not the only ones who are suffering. (**HORSE** *hands one baby twin glove to* **CHRISTMAS TREE** *and the other to* **NOSE**)

HORSE (HAY,) many people have witnessed a scene just like this before and so will many people after them. There is

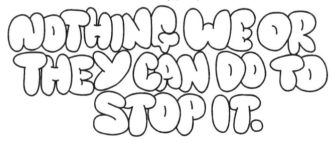

34. If you are a genius and have read all the footnotes (like all good geniuses do) then you'll know about the genius text.

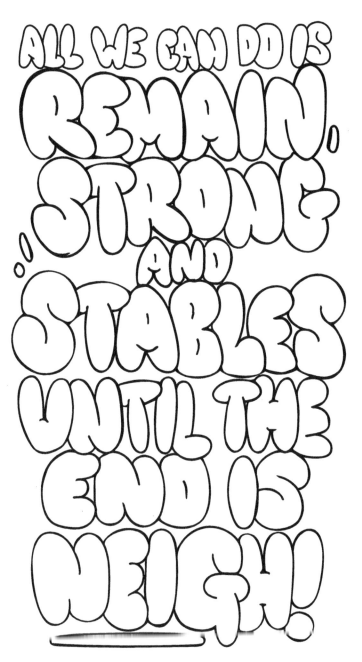

ALL WE CAN DO IS REMAIN, STRONG, AND STABLES UNTIL THE END IS NEIGH!

They revolve away.

Act 3

scene one
Je ne regreta rien

The revolve continues to turn to reveal **ALICE** *standing next to a vibrating exercise plate wearing a black unitard with an orange collar, orange bob wig and an orange cage skirt. She is holding the orange jelly from the March sisters' Christmas feast. The stage stops turning, leaving her standing centre stage. She places the jelly on the vibrating plate. She then picks up the electrical cord, plugging it in stage left. She comes back and switches the vibrating plate on. The jelly wobbles violently.*

ALICE *picks up the jelly and stands on the vibrating plate - now they both wobble violently. The karaoke backing track to Edith Piaf's 'Je ne regrette rien' begins to play.* **ALICE** *sings along with some additional lyrics taken from Little Women the novel and a perfect vibrato thanks to the vibrating plate.*

ALICE *(singing)* Non, rien de rien
Non, je ne regrette rien
Ni le bien, qu'on m'a fait
Ni le mal, tout ça m'est bien égal

Whilst **ALICE** *sings,* **SARAH**, **RACH P**, **RACH G** *and* **SUE** *enter and begin striking the set behind her. They are wearing the same black unitard with the orange collar, but without the cage skirt or the wigs. Instead they wear black wig caps. First they take the furniture and props, then they dismantle the wall into four sections and take those too. They draw the orange curtains and pelmet off stage. All that remains is the white backdrop and the penis luge on the trolley downstage right.* **RACH G** *lowers a heat lamp on a winch down from the rig, positioned exactly above the ice sculpture.*

ALICE *(singing)* Non, rien de rien
Non, je ne regrette rien
C'est payé, balayé, oublié
Je me fous du passé

ALICE *(spoken)* I only mean to say
That I think it never was intended I should live that long.
I am not like the rest of you.
I never thought about what I would do when I grew up.
I never thought of getting married.
I couldn't seem to imagine myself anything but
Stupid Little Beth.
Trotting about at home
Of no use to anyone anywhere but there.
I never wanted to go away
And the hard part now is leaving you all.
I am not afraid
But it seems as if I should be homesick for you
Even in heaven.

(singing) Non, rien de rien
Non, je ne regrette rien
Ni le bien, qu'on m'a fait
Ni le mal, tout ça m'est bien égal!

Once they have finished striking the set, **SARAH**, **RACH P**, **SUE**
and **RACH G** *exit. Leaving* **ALICE** *alone once more.*

ALICE *(singing)* Non, rien de rien
Non, je ne regrette rien
Car ma vie, car mes joies
Aujourd'hui, blah blah blah, blah blah blahhhhh

The music ends.

scene two
Wind turbine

SARAH, **RACH P**, **RACH G** and **SUE** enter. They are now also wearing orange cage skirts and wigs and holding giant orange plastic straws which are actually whirly tubes - a children's toy that makes a musical noise when you spin it round and round. **SARAH** and **RACH P** help **ALICE** move the vibrating plate and its jelly to downstage left.

The **FIGS**[35] stand still, spread out across the stage. They each hold an orange whirly tube in one hand which they begin to spin. As they spin, the whirly tubes create a wind-like sound, a single musical note - the faster the tube spins the higher the note. Together they spin the tubes at random speeds creating a windy soundscape of whooshes and haunting notes.[36]

After about 45 seconds of the whirly tubes the Wind Turbine track starts. It begins with low whooshing sounds that are reminiscent of the giant blades of a wind turbine, slicing through the air.[37] The **FIGS** exit the stage still spinning the whirly tubes. The beat of the music kicks in and the **FIGS** return, without the tubes and begin the Wind Turbine dance.

The music is repetitive, haunting and ominous. It incorporates slowed down wind sounds,[38] intermittent slashes of metallic sounds, and a heavy plodding baseline that goes: dum di DUM dum DUM

35. The Figs refers to Alice, Sarah, Suzanna, Rachel and Rachel who work for the company Figs in Wigs LLP.
36. If you have never heard what a whirly tube sounds like then you're in luck because YouTube has a plethora of options for you to listen to. Go check them out. Double you double you double you dot youtube dot com.
37. In actual fact this wind turbine sound FX was created by Suzanna using the recorded sounds of a hairdryer.*
38. No we don't mean farts. You're getting confused with our other seminal 2k19 theatre show Wind in the Willows, in which small woodland creatures use their own flatulence to power a rocket ship from Venus to Earth.
* In actual actual fact the hairdryer sound wasn't whooshy enough so she downloaded a sound from the internet.

The choreography has been inspired by wind turbines and the wind that moves them. There are strong geometric arms, small steps and robot-like head turns and spins. At first they are disparate, moving like solitary wind turbines on a horizon. Later they dance in complete synchronicity. Sometimes one or two of them break out in moments of canon but mostly the five of them are in perfect unison, or so they think.

To be more specific here are the specific names of the specific dance moves they perform:

Cod Army/Sue's Macarena[39]
Bunch of Sticks
CorkSCREW
Robot Ch
My Favourite Pair of Holiday Shoes
Arm-ish Windmill/Original Diagonal
Underwater Surprise Kick
Hofesh Schecter
Slow Sniff & Whiff
Don't Look Back (You're Not Going That Way)
Original Gammon
My Other Favourite Pair of Holiday Shoes
Sue's Sexy Warrior
Peek & Leap
Ibiza Chicken
Alice Original Jumpy
Ripple & Step
My Butterfly Shoes

The cage skirts bounce, wobble and swing out of time with the music, which complements and contrasts the dance. The black suits stand out against the white backdrop, warm side lights cast shadows of the performers, an army of figs silhouetted behind them, dancing together.

The jelly is still jiggling on the vibrating plate downstage attempting to steal the show.

*The music ends. The **FIGS** whoosh off leaving an empty stage. An epic video aka the Epic Vid plays on the white backdrop.*

39. See page 84 for a diagram of this move.

scene three
Epic Vid

*The Epic Vid contains snippets from the Little Women movie adaptations layered with dramatic scenes of world disasters such as erupting volcanoes, the death of bees, and avalanches. The **FIGS** are also seen in the video crying their eyes out in orange ballroom dresses. The soundtrack to the movie is an incredibly slowed down version of the classical music used in the earlier scene: The Ball (Or Meg's Hen Party).*

scene four
Lime experiment [40]

The **FIGS** *enter upstage left in single file in this order:* **SARAH**, **ALICE**, **RACH P**, **RACH G**, **SUE**. *They are wearing shiny orange hazmat boiler suits. The boiler suits are loud and crispy. They stop and stand in a line, just in front of the white backdrop, nicely spaced out, facing the audience.*

One
 hu
 ndr
 ed
and fif
 ty
 l
 i
 m
 e s
 d
 r
 op
 fr om
 the
 ligh ting
 rig
 on
 to th
 e

 stage.

The **FIGS** *do not react.* [41]

40. Our band Beth and the Burdens have a song called Live Experiment. At one point we thought we should change the lyrics to Lime Experiment, and the limes would fall from the lighting rig at the end of the song.
41. They knew what was coming you see. This was their idea.

A pause.

*The **FIGS** all turn on their heels and perform the next three stage directions simultaneously:*



SUE exits stage left and immediately returns wheeling out a small cake trolley completely overloaded with musical equipment. There's a KORG Monologue (synth), a loop pedal, a microphone and a multitude of dangling wires making it hard to navigate. She parks the trolley downstage left and turns on the KORG Monologue - a bubbling blibbidy blobbidy laboratory-esque sound...

***RACH G** and **RACH P** wheel on a metal catering trolley from upstage left to downstage centre. On the top shelf of the trolley is a container of table salt. On the bottom shelf of the trolley is a cauldron.[42] Together, they take the jelly off the vibrating plate and put it on the top shelf, they then pick up the cauldron from the bottom shelf and place it on the vibrating plate. Finally they lift the jelly and move it from the top shelf to the bottom shelf of the trolley. **RACH G** picks up the container of salt, turns it upside down and begins to pour a salt circle on to the top shelf of the trolley in an anti-clockwise direction.[43]*



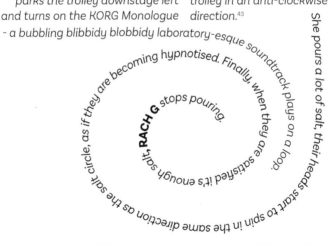

*...track plays on a loop. She pours a lot of salt, their heads start to spin in the same direction as the salt circle, as if they are becoming hypnotised. Finally, when they are satisfied it's enough salt, **RACH G** stops pouring.*

42. When we say a cauldron what we mean is a saucepan. It's a very large saucepan. Rachel Porter purchased it for £39.99 in 2018 for a New Year's Eve weekend away we organised for 33 of our friends. The saucepan was big enough to cook curry for 40 people, which is magic. So really it is a cauldron.

43. Originally the salt circle was going to be on the stage, more specifically on the revolve. And it would have been as big as our original cocktail glass was going to be. See footnote 46 for more details.

They both look pleased with themselves. **RACH G** *takes a pinch of salt that has escaped the circle and throws it over her left shoulder. They move the trolley upstage.*

ALICE *and* **SARAH** *push on another steel catering trolley from upstage right to downstage* centre. On the trolley is a commercial citrus juicing machine, the type you might find in canteens or cafes, namely the Zummo Pro ZO5. Underneath the juicer, in the lower part of the trolley, are five litter picking devices, the type that enable you to pick up litter from the floor without bending down.[44] They overshoot their mark and have a small tug of war over the spot at which the juicer should rest. This only takes a couple of tugs.

Once all three trolleys are in their final positions, the **FIGS** *all move downstage centre and gather around the juicer trolley. They each 'pick' a litter picker and use them to pick up the fallen limes and load them into the juicer. After they have deposited around 40 limes into the juicer, they place the litter pickers back on the trolley and the KORG blibbidy blobbidy soundtrack stops. They turn on the juicer. They watch in amazement as the juicer seamlessly slices and juices the limes one by one. The juice is*

44. Like a selfie stick, but much more selfless.

collected in a glass jug below. After 10 limes have been squeezed they speak...

RACH G In the past, what's happening now would have been performed manually by the little women, and would have been called task based performance, but now, with the Zummo Pro Z05 we barely have to lift a finger.

SUE Believe it or not the Zummo Pro Z05 is able to juice an astonishing 1.5 litres of 100% pure lime juice in just 60 seconds, making it the perfect machine for the fast-paced events.

SARAH That's right, the Zummo Z0Y0500 is amazing. It can squeeze up to 40 fruits a minute. Plus the stainless steel body makes it quick and easy to clean.

ALICE The unique patented vertical squeezing action of the Zummo Pro Z05 allows the fruit to be cut in half then squeezed without the juice coming into contact with the bitter peel. The result – fresh, natural fruit juice that tastes delicious.

RACH P We always say that the Zummo Pro Z05 adds a bit of theatre. Smart and contemporary-looking in stainless steel, I think we can all agree the Zummo Pro Z05 looks great. And it's fascinating to watch in action!

*The **FIGS** turn to look at the juicer at work, fascinated. They watch it intently, as if it's a good film.*

*Once the limes are juiced **RACH G** picks up the jug of lime juice and they all gather round the cauldron on the vibrating plate.*
***SARAH** removes the lid to reveal three bottles: Tequila, Cointreau and Sugar Syrup. **ALICE**, **RACH P** and **SARAH** each pick up a bottle and kneel by the cauldron. **SUE** wheels the musical equipment to the vibrating plate and uses the microphone to record each fig as they pour their chosen liquid into the cauldron. Using the loop pedal she layers the liquid noises on top of each other. She records the following sequence of events on to the loop pedal, creating a layered soundtrack that builds as the scene unfolds:*

The vibrating plate is turned on, becoming a homemade cocktail shaker, mixing all the liquids together. **SARAH** *places the lid back on it. The lid rattles, shattering the serene yet suspenseful environment.*

They move downstage right to the now somewhat melted penis vodka luge. **ALICE** *collects a hammer and chisel from off stage right and brings them to the luge.*[45] *Taking turns they each use the hammer and chisel to chip away at the semifreddo phallus.* **SARAH**, *who played* **AMY** *earlier in the show, smashes the penis into smithereens. Once smashed* **RACH G** *takes hold of the trolley and the others form a conga line behind her. Together they conga with the trolley covered in smashed cock ice to the cauldron.* **RACH G** *lifts the lid of the cauldron and one by one the others plop a piece of ice inside.*

ALICE *moves the juicer upstage left whilst* **RACH P** *brings on a giant cocktail glass to centre stage.*[46] *As they cross paths* **ALICE** *hands her one of the empty squeezed lime halves.* **RACH P** *rubs the rim of the glass with the lime half whilst* **SARAH** *whirls one of the whirly tubes to create a 'glass harp' sound effect.*[47] **RACH P** *then turns the glass upside down into the salt circle, turning the glass until the rim is coated in salt.*[48]

45. We'd thought a lot about the breaking of luge and what best represents us smashing the patriarchy. Originally we were going to use blow torches which calls back to the elements of the show. Another idea would be that we each individually piss on the luge using a Shewee™, slowly melting the sculpture with hot urine. After some concerns about fire risks, and our ability to wee on command we reverted to the hammer and chisel.

46. When we say "giant cocktail glass" what we mean is an 80cm tall cocktail glass. Of course, this is still giant in comparison to the average cocktail glass, but originally we'd hoped for a margarita glass roughly the size of the one that stars in Beyonce's raunchy music video for her hit single Naughty Boy; namely big enough to accommodate her entire body. Our glass was big enough to accommodate the entire body of our friend Maia, but she was only 5 months old at the time. Originally we were going to lower the cocktail glass upside down from the lighting rig onto the salt circle on the stage, the stage would revolve and the glass would be rimmed in this manner. But our dreams were crushed when some smart Alec (Helen, our production manager) suggested it might be too dangerous to have a giant glass hanging above our heads for two hours and then flown in every night. What a shame.

47. If you don't know what a glass harp is, please refer to our 2013 seminal performance work 'We, Object' or watch Miss Congeniality or Google it.

48. At one point in the process, we had planned to project the words RIM

ALICE and **RACH G** remove the ice from the cauldron. **RACH
G** lifts the cauldron and pours the mix into the giant
cocktail glass. **SUE** puts down the microphone
and the soundscape is complete; the
cacophony of loops continues to play
until **SARAH** hands a plastic straw
to each fig. They cheers by
smacking their straws tog
ether, then place the
straws into the
glass and
begin
t o
drink
t h e
frozen
Marg
aret-
burp
ing,
slurp

 ing, chok

ing and chugg

i n g .

It takes some time...

JOB on the back wall whilst we created this salty rim. But we never did it
in the end.

It's a very big glass...

When they have finished....

RACH P　　　　And that concludes our adaptation of Little Wimmin. Any questions?

Blackout.

The End

RECOMMENDED WATCH LIST

Little Women (all versions)

Peter Sage's TED talk - Stop Waiting for Life to Happen (available on Youtube)

Philadelphia advert with Caroline Quentin, circa 2000 (available on Youtube)

The Angelic Initiative, Episode 710 - Cool & Uncool Trees (available on Youtube)

BBC Director, Fergus Beeley, places everybody under citizens arrest (available on Youtube)

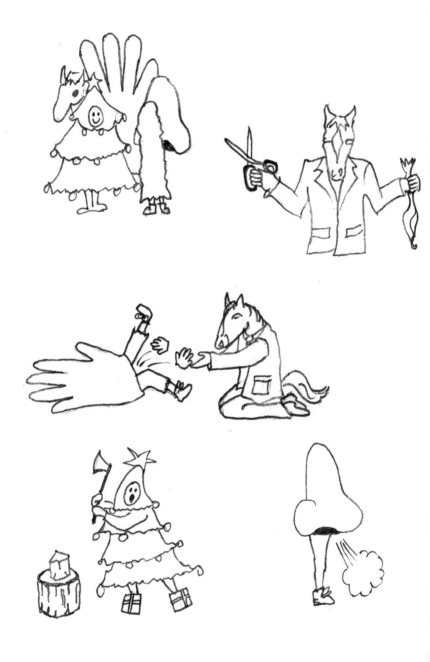

SENSE

SENSE

NONSENSE

NONSENSE

Direct Address begins once stage is cleaned up.
'Amy's Valley of Humiliation' appears on back wall
of Fire. They tell the story of the chapter
Morgue table on wheels, orange rubber gloves.
Turn the tables in this scene. Spank the patriarchy in
this scene. Get all the men to line up (or maybe not
as clear cut, more like Dumptive Women) Have anyone
people who went to university etc. Tell them they are
gonna get spanked - then softly joking sit back down.
Say something very clever about the patriarchy & how
spanking members of the public isn't going to fix it
Wheel on juice and explain the Anthropocene, what
Patriarchy has done to the earth. Astrology 2020 going
into air signs. Less about fossil fuels more about
renewable energy and plenty in space ya know?
Why was the book popular even though it was so much?
Because it wrote mostly about women with independent
thoughts and feuills when Patriarchy was at it's peak.
Even though she didn't want to into it. They are
ambitious and have dreams for their public though
as girls in novels they have to be married off.

} tab tracks at back of stage?
} how many backdrops do we need?

£25 - trolley Ikea

white backdrop -
x2

Production Meeting again.

Need a door in real life!
with actual doors

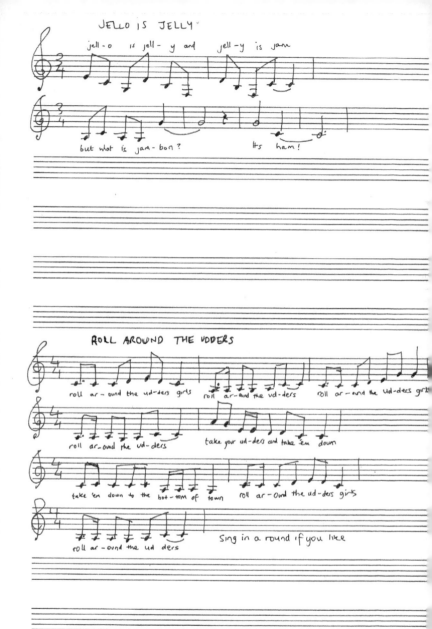

Sue's Macarena

Audience in front, turn to right for starting position

→ → → →

Jump to front ↑ ↑↑

Hand on shoulder, bend the knees

Step round on spot, anticlockwise 225° or 37.5 min

↖↑ for a count of 8
↙↓↘

↓ jump

↓ jump
↓ jump

pause

look over left shoulder and walk

↘ walk for 8

jump to front

↑ ↑↑

jump jump

Initial designs by Emma Bailey

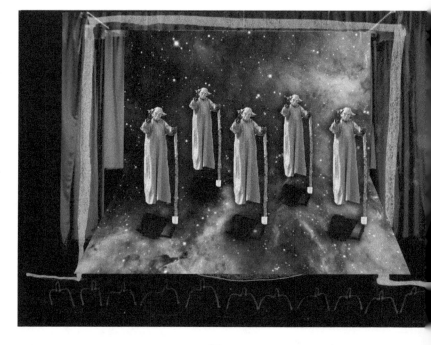

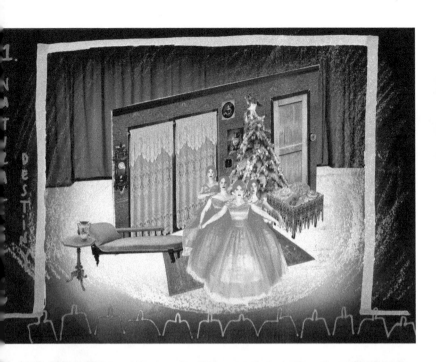

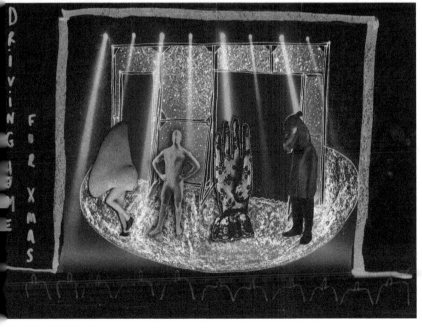

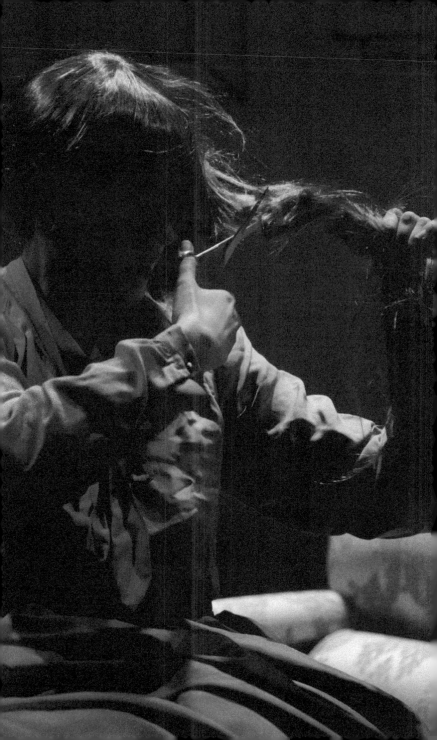

Below The Floating Oracles
Left Naturalistic Destiny
Part One: Jo Cuts Her Hair

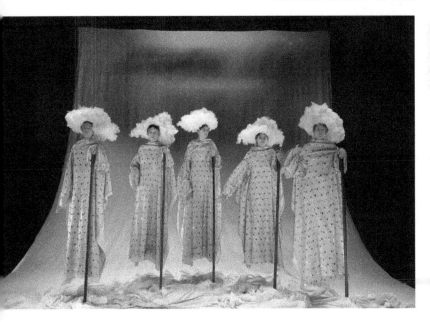

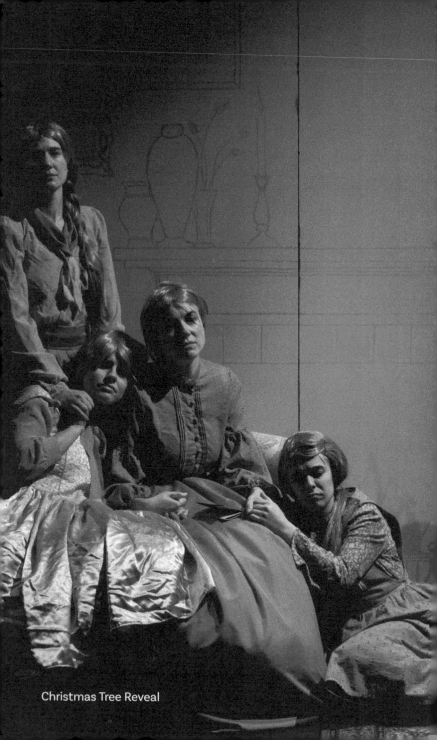

Christmas Tree Reveal

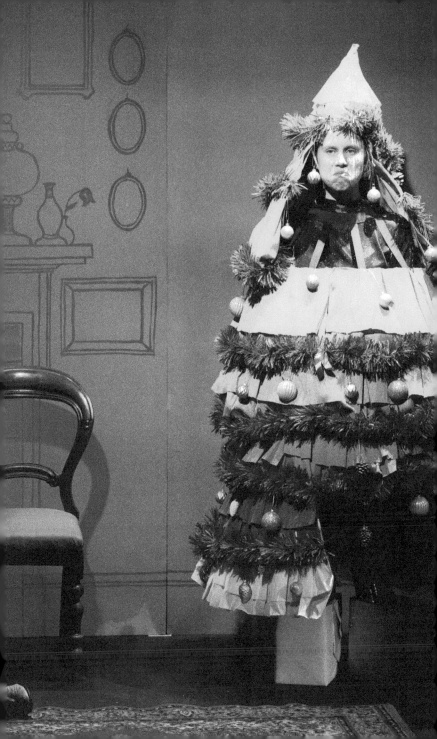

Bellow Meg's Hen Party
Top right Naturalistic Destiny
Part One
Bottom right Driving Home for
Naturalistic Destiny Part Two

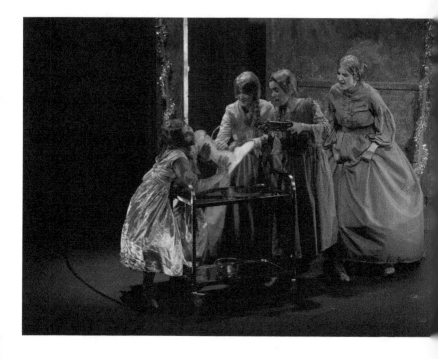

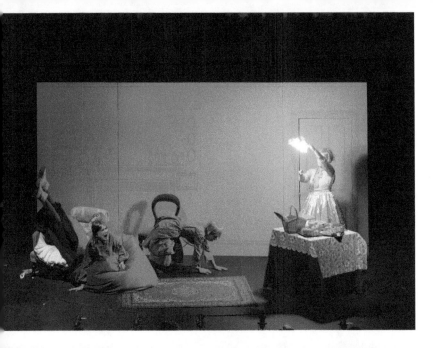

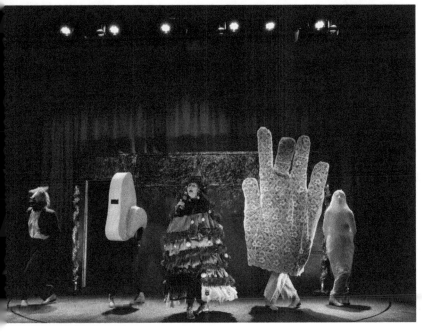

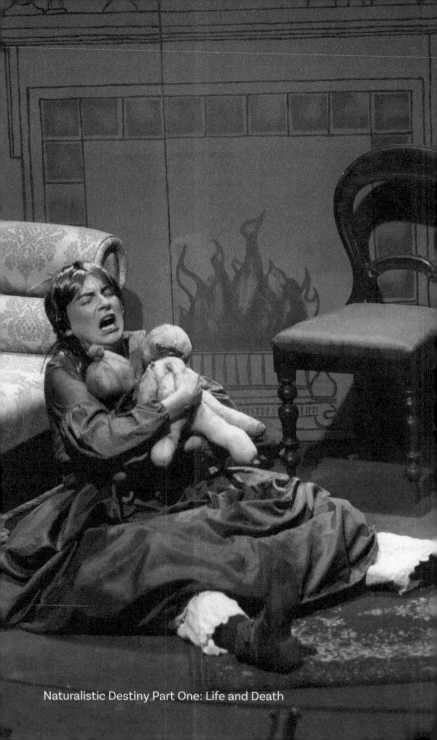

Naturalistic Destiny Part One: Life and Death

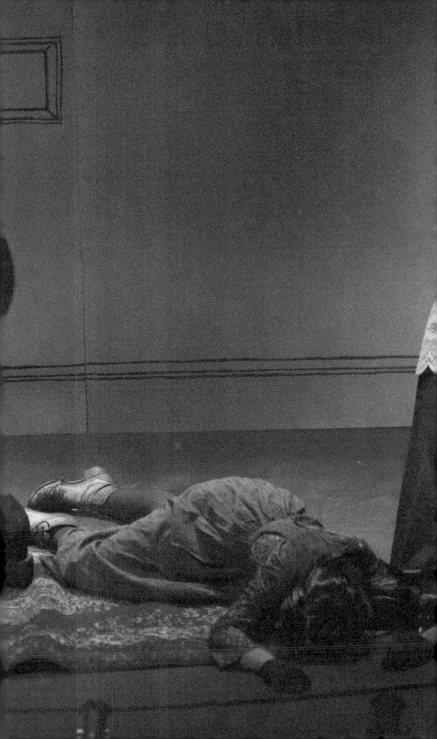

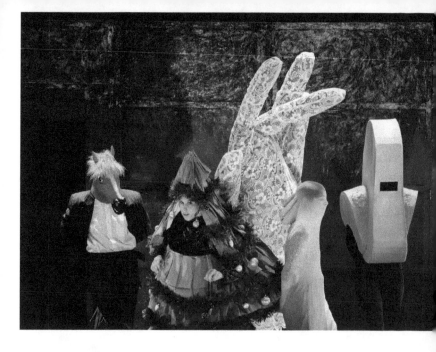

Bellow Lime Experiment
Top right Still from Epic Vid
(Wind Turbine)
Bottom right Still from Epic
Vid (Crying on posts)

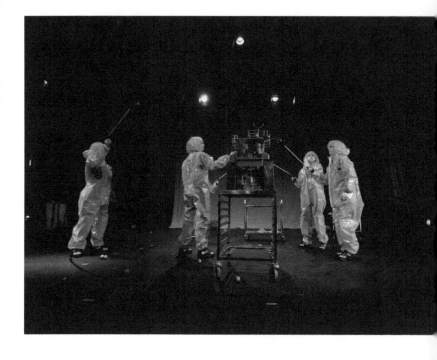

Bellow Lime Experiment
Top right Making the Margaret
Bottom right Drinking the Margaret

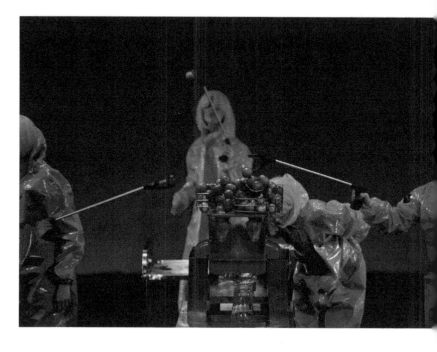

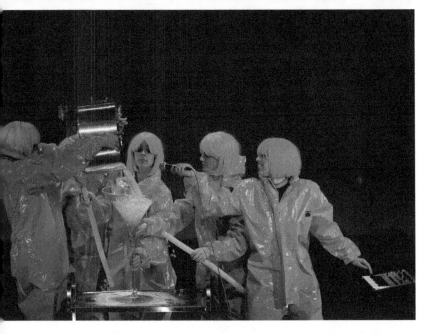

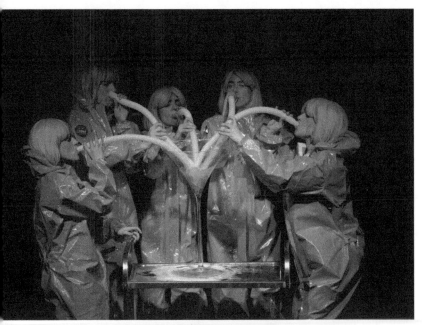

Dear Reader,
Thank you for getting this far and for reading our play. The end is nigh (the next page is the last). If you have any questions or compliments please send them to figs@figsinwigs.com

Thank you and goodbye!

Fig love,
Figs in Wigs

www.ingramcontent.com/pod-product-compliance
Lightning Source LLC
Jackson TN
JSHW061344131224
75386JS00053B/1815